Draw Interiors

MARY SEYMOUR

Series editors: David and Brenda Herbert

A & C Black • London

First published in 1981
New style of paperback binding 1997
By A&C Black Publishers Limited
38 Soho Square, London W1D 3HB
www.acblack.com

Reprinted 1999, 2004, 2007

ISBN-10: 0-7136-8305-8
ISBN-13: 978-0-7136-8305-9

Cover design by Emily Bornoff

Printed in China by WKT Company Limited

This book is produced using paper that is made from
wood grown in managed, sustainable forests. It is natural,
renewable and recyclable. The logging and manufacturing
processes conform to the environmental regulations
of the country of origin.

Contents

Making a start

Learning to draw is largely a matter of practice and observation—so draw as much and as often as you can, and use your eyes all the time.

Look around you—at chairs, tables, plants, people, pets, buildings, your hand holding this book. Everything is worth drawing. The time you spend on a drawing is not important. A ten-minute sketch can say more than a slow, painstaking drawing that takes many hours.

Carry a sketchbook with you whenever possible, and don't be shy of using it in public, either for quick notes to be used later or for a finished drawing.

To do an interesting drawing, you must enjoy it. Even if you start on something that doesn't particularly interest you, you will probably find that the act of drawing it—and looking at it in a new way—creates its own excitement. The less you think about how you are drawing and the more you think about what you are drawing, the better your drawing will be.

It is often difficult to start when confronted with a clean sheet of paper; reluctance to 'spoil' all that purity can be inhibiting. If this is so, have several sheets to hand; you probably won't use them all but you will feel freer to make a mess. Plunge straight in; the first mark is often the most difficult to make and once it is down, all the other marks will develop round it.

The best equipment will not itself make you a better artist – a masterpiece can be drawn with a stump of pencil on a scrap of paper. But good equipment is encouraging and pleasant to use, so buy the best you can afford and don't be afraid to use it freely.

Be as bold as you dare. It's your piece of paper and you can do what you like with it. Experiment with the biggest piece of paper and the boldest, softest piece of chalk or crayon you can find, filling the paper with lines—scribbles, funny faces, lettering, anything—to get a feeling of freedom. Even if you think you have a gift for tiny delicate line drawings with a fine pen or pencil, this is worth trying. It will act as a 'loosening up' exercise. The results may surprise you.

Be self-critical. If a drawing looks wrong, scrap it and start again. A second, third or even fourth attempt will often be

better than the first, because you are learning more about the subject all the time. Use an eraser as little as possible—piecemeal correction won't help. Don't re-trace your lines. If a line is right the first time, leave it alone—heavier re-drawing leads to a dull, mechanical look.

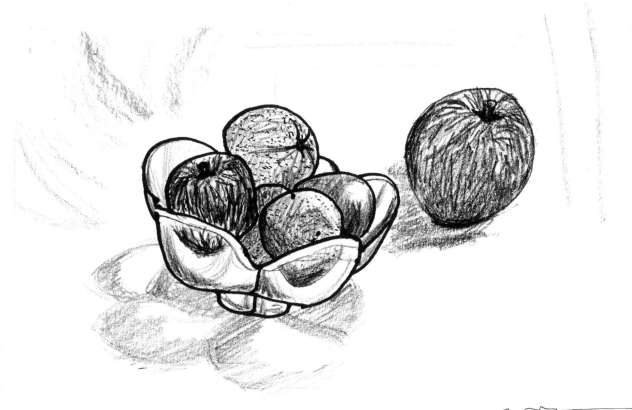

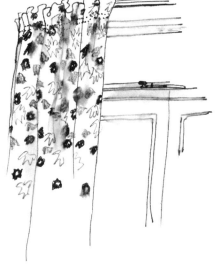

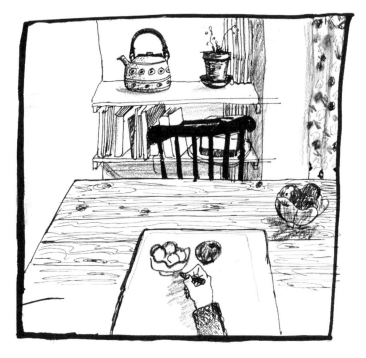

Try drawing in colour. Dark blue, reddish-brown and dark green are good drawing colours. A coloured pencil, pen or chalk can often be very useful for detail, emphasis or contrast on a black and white drawing.

You can learn a certain amount from copying other people's drawings. But you will learn more from a drawing done from direct observation of the subject or even out of your head, however stiff and unsatisfactory the results may seem at first.

Doors are a good subject to start with. Draw them shut, open and half-open. An open door can make a good composition—acting as a frame for the view beyond.

Then practise drawing quick, thumbnail sketches of a room's shape—ignoring details for the moment, in order to gain confidence and get your eye in.

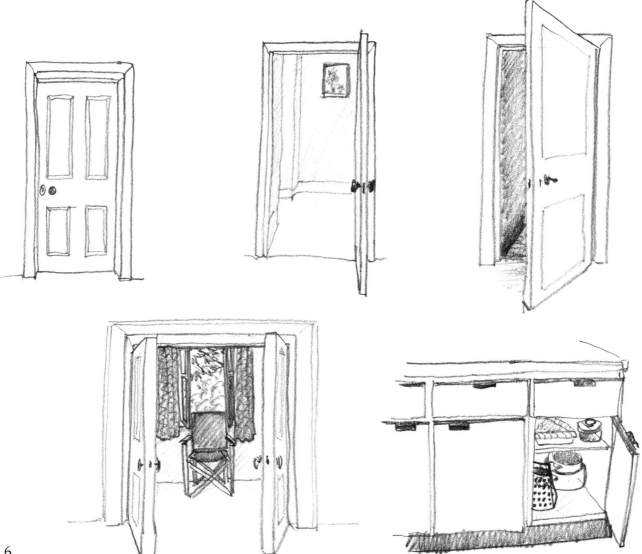

A lot can be learned by practice and from books, but a teacher can be a great help. If you get the chance, don't hesitate to join a class—even one evening a week can do a lot of good.

What to draw with

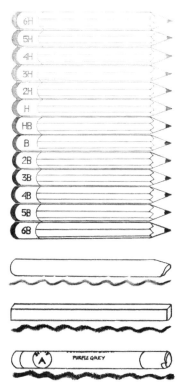

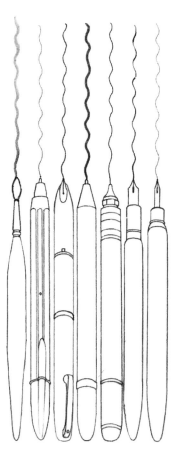

Pencils are graded according to hardness, from 6H (the hardest) through 5H, 4H, 3H, 2H to H; then HB; then B, through 1B, 2B, 3B, 4B, 5B up to 6B (the softest). For most purposes, a soft pencil (HB or softer) is best. If you keep it sharp, it will draw as fine a line as a hard pencil but with less pressure, which makes it easier to control. Sometimes it is effective to smudge the line with your finger or an eraser, but if you do this too much the drawing will look woolly. A fine range of graphite drawing pencils is Royal Sovereign.

Charcoal (which is very soft) is excellent for large, bold sketches, but not for detail. If you use it, beware of accidental smudging. A drawing can even be dusted or rubbed off the paper altogether. To prevent this spray with fixative. Charcoal pencils, such as the Royal Sovereign, are also very useful.

Wax crayons (also soft) are not easily smudged or erased. You can scrape a line away from a drawing on good quality paper, or partly scrape a drawing to get special effects.
Oil pastels, marker pencils, chinagraph and lithographic chalk are similar to wax crayons.

Conté crayons, wood-cased or in solid sticks, are available in various degrees of hardness, and in three colours – black, red and white. The cased crayons are easy to sharpen, but the solid sticks are more fun—you can use the side of the stick for large areas of tone. Conté is harder than charcoal, but it is also easy to smudge. The black is very intense.

Pastels (available in a wide range of colours) are softer still. Since drawings in pastel are usually called 'paintings', they are really beyond the scope of this book.

Pens vary as much as pencils or crayons. Ink has a quality of its own, but of course it cannot be erased. Mapping pens are only suitable for delicate detail and minute cross-hatching. Special artists' pens, such as Gillott 303 and Gillott 404 allow you a more varied line, according to the angle at which you hold them and the pressure you use. The Gillot 659 is a very popular crowquill pen.
Reed, bamboo and quill pens are good for bold lines and you can make the nib end narrower or wider with the help of a sharp knife or razor blade. This kind of pen has to be dipped frequently into the ink.

Fountain pens have a softer touch than dip-in pens, and many artists prefer them. The portability of the fountain pen makes it a very useful sketching tool.

Special fountain pens, such as Rapidograph and Rotring, control the flow of ink by means of a needle valve in a fine tube (the nib). Nibs are available in several grades of fineness and are interchangeable. The line they produce is of even thickness, but on coarse paper you can draw an interesting broken line similar to that of a crayon. These pens have to be held at a right-angle to the paper, which is a disadvantage.

Inks also vary. Waterproof Indian ink quickly clogs the pen. Pelikan Fount India, which is nearly as black, flows more smoothly and does not leave a varnishy deposit on the pen. Ordinary fountain-pen or writing inks (black, blue, green or brown) are less opaque, so give a drawing more variety of tone. You can mix water with any ink in order to make it thinner. But if you are using Indian ink, add distilled or rain water, because ordinary water will cause it to curdle.

Ball point pens make a drawing look a bit mechanical, but they are cheap and fool-proof and useful for quick notes and scribbles.

Fibre pens are only slightly better, and their points tend to wear down quickly.

Brushes are most versatile drawing instruments. The Chinese and Japanese know this and until recently never used anything else, even for writing. The biggest sable brush has a fine point, and the smallest brush laid on its side provides a line broader than the broadest nib. You can add depth and variety to a pen or crayon drawing by washing over it with a brush dipped in clean water.

Mixed methods are often pleasing. Try making drawings with pen and pencil, pen and wash or Conté and wash. And try drawing with a pen on wet paper. Pencil and Conté do not look well together and Conté will not draw over pencil or greasy surfaces.

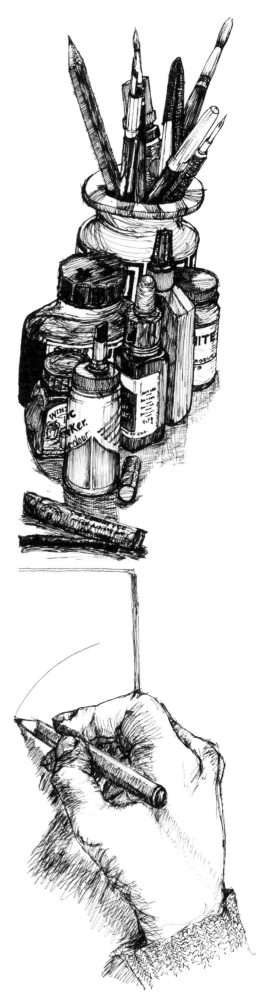

What to draw on

Try as many different surfaces as possible.

Ordinary, inexpensive paper is often as good as anything else: for example, brown and buff wrapping paper (Kraft paper) and lining for wallpaper have surfaces which are particularly suitable for charcoal and soft crayons. Some writing and duplicating papers are best for pen drawings. But there are many papers and brands made specially for the artist.

Bristol board is a smooth, hard white board designed for fine pen work.

Ledger Bond paper ('Cartridge' in the UK), the most usual drawing paper, is available in a variety of surfaces—smooth, 'not surface' (semi-rough), rough.

Watercolour papers, also come in various grades of smoothness. They are thick, high-quality papers, expensive but pleasant to use.

a. Caran d'ache chalk on thick watercolour paper

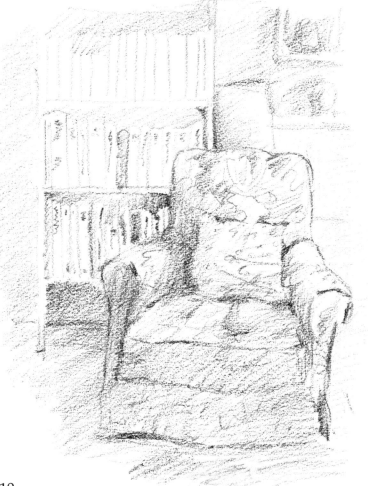

b. Charcoal on smooth paper

Ingres paper is mainly for pastel drawings. It has a soft, furry surface and is made in many light colours—grey, pink, blue, buff, etc.

Sketchbooks, made up from nearly all these papers, are available. Choose one with thin, smooth paper to begin with. Thin paper means more pages, and a smooth surface is best to record detail.

Lay-out pads make useful sketchbooks. Although their covers are not stiff, you can easily insert a stiff piece of card to act as firm backing to your drawing. The paper is semi-transparent, but this can be useful—almost as tracing paper—if you want to make a new, improved version of your last drawing.

An improvised sketchbook can be just as good as a bought one—or better. Find two pieces of thick card, sandwich a stack of paper, preferably of different kinds, between them and clip together at either end.

c. Fountain pen on smooth paper

d. Charcoal on thick watercolour paper

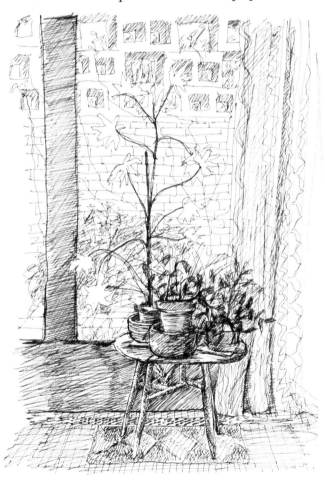

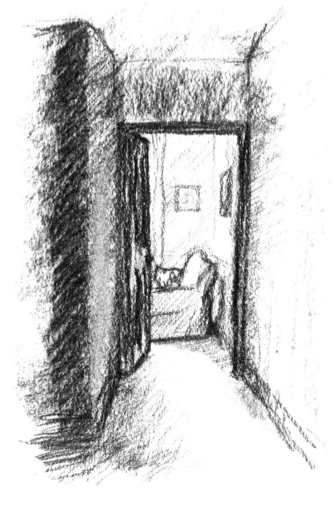

Perspective

You can be an artist without knowing anything about perspective. Five hundred years ago, when some of the great masterpieces of all time were painted, the word did not even exist. But most beginners want to know something about it in order to make their drawings appear three-dimensional, so here is a short guide.

The further away an object is, the smaller it seems.

All parallel horizontal lines directly opposite you, at right-angles to your line of vision, remain parallel.

All horizontal lines that are in fact parallel but go away from you will appear to converge at eye-level at the same vanishing point on the horizon. Lines that are above your eye-level will seem to run downwards towards the vanishing point; lines that are below your eye-level will run upwards. You can check the angles of these lines against a pencil held horizontally at eye-level.

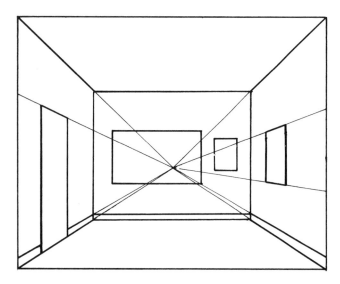 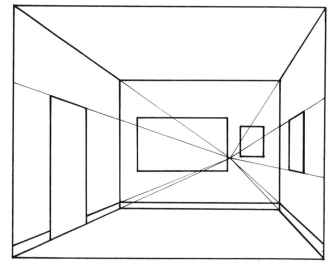

The larger and closer any object is, the bigger the front of it will seem to be in relation to the part furthest away, or to any other more distant object. Its actual shape will appear foreshortened or distorted. A matchbox close to you will appear larger and more distorted than a distant house, and if you are drawing a building seen at an angle through a window, the window frame will be larger and more distorted than the building.

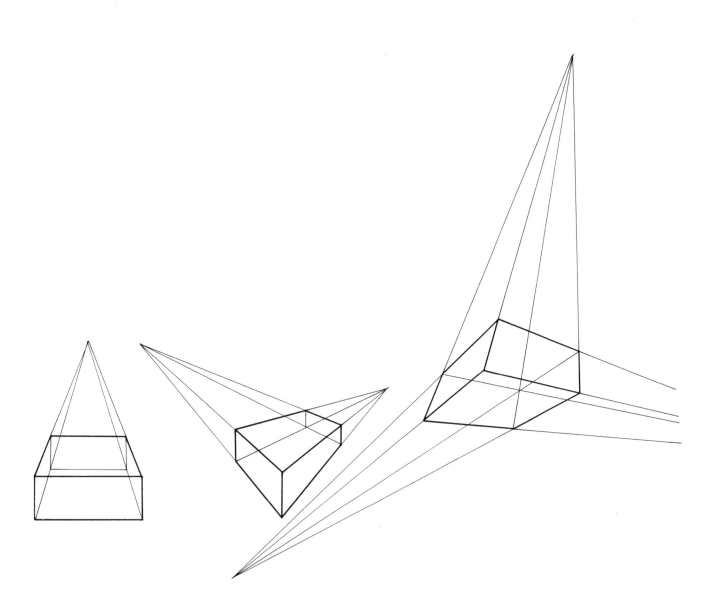

If the side of an object is facing you, one vanishing point is enough, but if the corner is facing you, two vanishing points will be needed.

It may even be necessary to use three vanishing points when your eye is well above or below an object, but these occasions are rare.

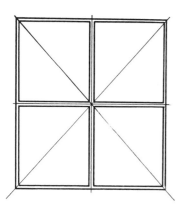

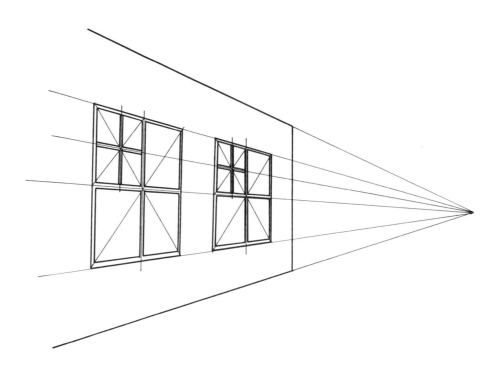

Diagonal lines drawn between the opposite angles of a square or rectangle will meet at a point which is half-way along its length or breadth. This remains true when the square or rectangle is foreshortened. You may find it helpful to remember this when you are drawing surfaces with equal divisions—for example, a tiled floor or the divisions between window panes—or deciding where to place windows on a façade.

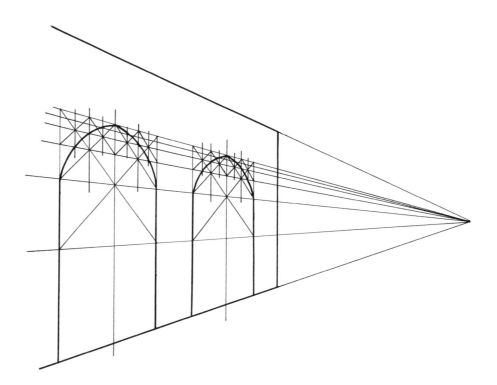

When drawing a circular shape, the following is useful: a circle drawn inside a square will touch the square at the centre point of each of its sides. A foreshortened circle will turn into an oval, but will still touch the centre points of each side of a similarly foreshortened square. However distorted the square, the circle will remain a true oval but will seem to tilt as the square moves to left or right of the vanishing point. The same is true of half circles.

Here is a common mistake and how to sort it out yourself. Most beginners will draw a cube, a chair, a table like the left-hand drawings opposite.

You will tend to exaggerate the apparent depth of top surfaces because you know they are square or rectangular and want to show this in your drawing.

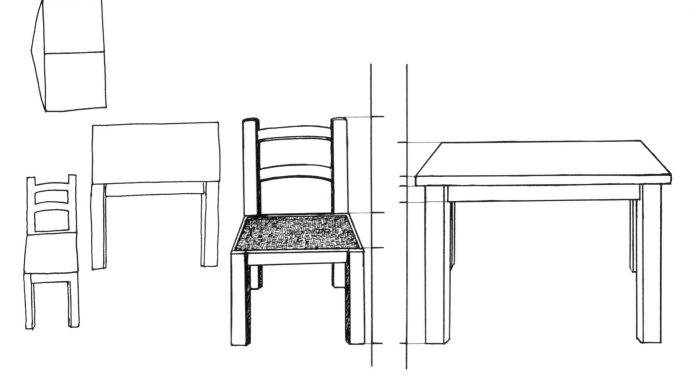

You can check the correct apparent depth of any receding plane by using a pencil or ruler held at eye-level and measuring the proportions on it with your thumb. If you use a ruler you can actually read off the various proportions.

One point to mention again: all receding parallel lines have the same vanishing point. So when you draw a room this will apply to all the horizontal edges—ceiling, doors, windows, floor level.

Composition

This does not only apply to large finished paintings. Deciding where to place even the smallest sketch or doodle on a scribbling pad involves composition. The effect of your drawing will be greatly influenced by its position on the paper and by how much space you leave around it.

It is generally best, when learning to draw, to make your drawing as large as possible on your piece of paper. But there are many possibilities. Sometimes you may not even want the whole of the object on your paper. And there is no reason why the paper should be the same shape as the subject—it is not, for instance, necessary to draw a tall object on an upright piece of paper.

When you are drawing more than one object on a sheet of paper, the placing of each object is also important. Try as many variations as possible.

Before you begin a drawing, think about how you will place it on the paper—even a few seconds' thought may save you having to start your drawing again.

Never distort your drawing in order to get it all in, or you will end up with a short-legged table or a peculiar-shaped room and wonder why it looks wrong.

Before starting an elaborate drawing, do a few very rough sketches of the main shapes to help you decide on the final composition. When you have decided which to use, rule a faint network of lines—diagonal, vertical and horizontal—over this preliminary sketch and on the piece of paper to be used for the finished drawing. (Take care that both pieces of paper are the same proportion.) You will then have a number of reference points to enable you to transfer the composition to the final drawing.

Rules are made to be broken. Every good artist is a good artist at least partly because of his originality; in fact, because he does what no one else has done before and because he breaks rules.

Every human being is unique. However poor an artist you think you are, you are different from everyone else and your drawing is an expression of your individuality.

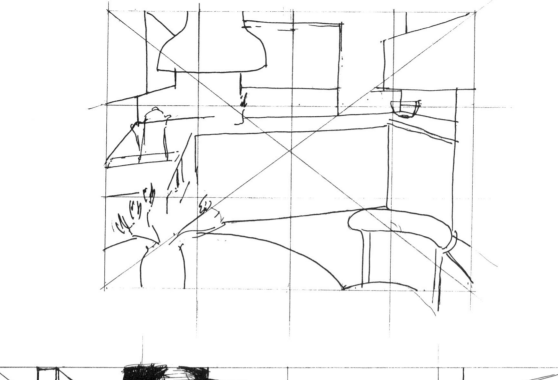

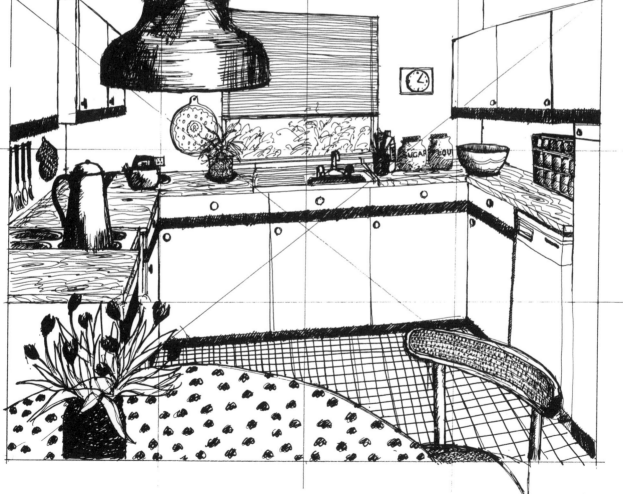

Step by step: the basic approach

Before you start drawing a scene, analyse your subject. Move a chair to a different position if you think it will look better, draw back a curtain more tightly, find another ornament if the mantelpiece looks bare, or, perhaps, place an object in the foreground both for interest and to give contrast in size.

Use a larger piece of paper than you think you will need so that there will be no fear of your drawing going off the edge, and remember to allow enough paper for the ceiling and floor even if you are not going to draw much of either. If you don't do this, your drawing may look cramped even though all your drawn marks are there. It is important when drawing a room to indicate space.

It sometimes helps to compose your picture if you hold up against the scene a piece of card with a rectangular hole cut in it. Doing this can make it easier to decide what to include—how much ceiling and floor, and how much of each side of the room.

Get the correct relationships between the objects. Measure on your page, using your pencil as a guide, the distance between the principal points of reference—say, a piece of furniture and the corner of the room. Using these points, map out the basic framework before attempting to start on details.

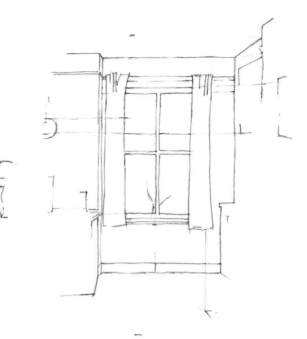

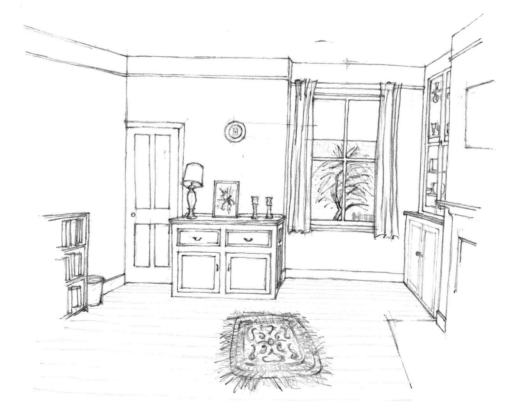

Under-standing how things work

A quick drawing will often be more lively than a slower, more painstaking one. But even a quick drawing needs to show that you have truly observed your subject. Have a close look at this subject first of all, to understand how it has been constructed.

Both these lamps bend, but each in a different way. The bigger one bends only from two simple ball-and-socket joints; the smaller one has a flexible section. Understanding basic design characteristics like these makes it easier to draw convincingly.

The drawings below show two different ways of joining a leg to a frame—the table with a wing nut, visible only from the underside, and the corner of the box bed with two large and visible bolts. This is useful information.

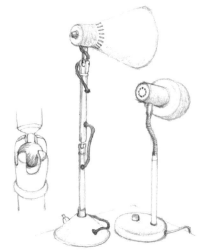

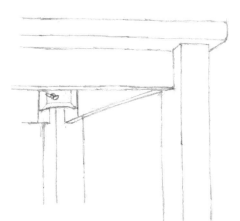

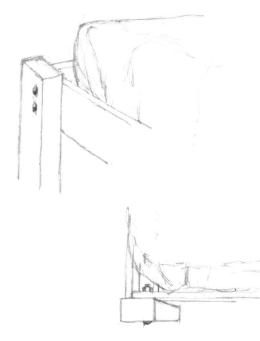

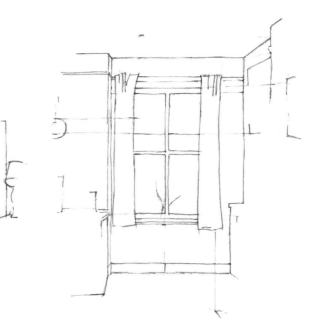

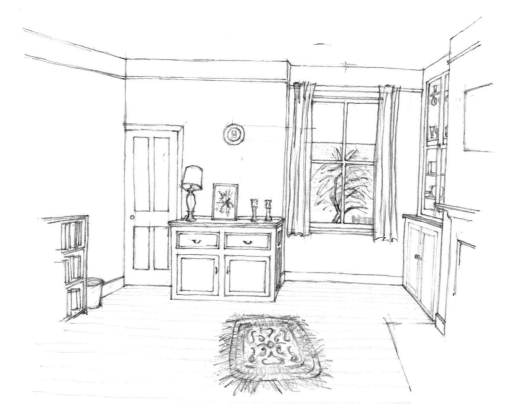

Under-standing how things work

A quick drawing will often be more lively than a slower, more painstaking one. But even a quick drawing needs to show that you have truly observed your subject. Have a close look at this subject first of all, to understand how it has been constructed.

Both these lamps bend, but each in a different way. The bigger one bends only from two simple ball-and-socket joints; the smaller one has a flexible section. Understanding basic design characteristics like these makes it easier to draw convincingly.

The drawings below show two different ways of joining a leg to a frame—the table with a wing nut, visible only from the underside, and the corner of the box bed with two large and visible bolts. This is useful information.

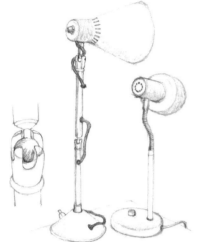

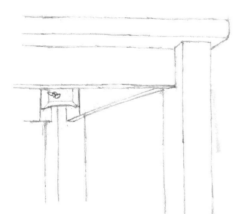

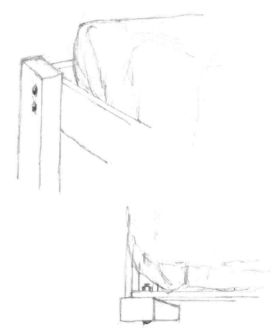

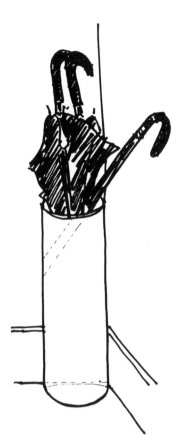

Look at the two drawings of the bolt below. In the first, the brackets look as if they were made for a bolt with a semi-circular cross section, and there is not enough space for the bolt itself to draw back properly. Likewise, in the first sketch of the umbrella stand, the walking stick has been drawn at such an angle that it couldn't possibly fit into the stand; and there is no room in the corner for an object of this shape to appear to be standing on the floor. Unless you look carefully at your subject before drawing, you may be disappointed with the final result without quite knowing why.

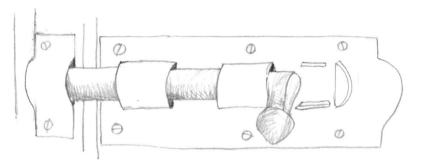

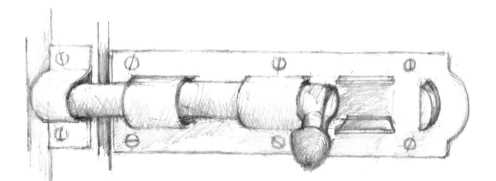

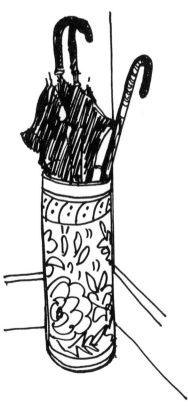

All the drawings on these pages are as rough as each other, but the ones that 'work' best are the ones that show the best understanding of how their subjects 'work'. Learning to observe closely is more important than learning how to make neat, tidy lines.

If you extend the back legs of the table in the first drawing, they won't meet the corners of the table.

The floor line of the top drawing (right) is too low, and the table's back legs float in air. Also the table is apparently drawn from above, and the objects on it from the side.

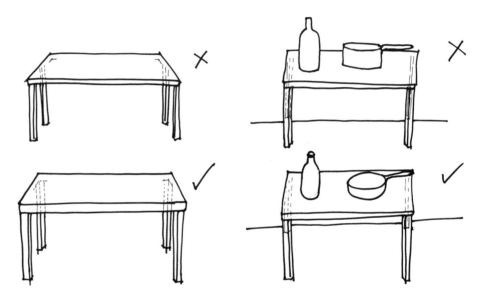

The top bowl (left) eats into the wall; there isn't enough space for it on the shelf. The right hand set of shelves demonstrates that one sees more or less of each shelf's top or bottom surface, according to whether it is above or below eye level; and the amount you see of an object on a shelf varies similarly.

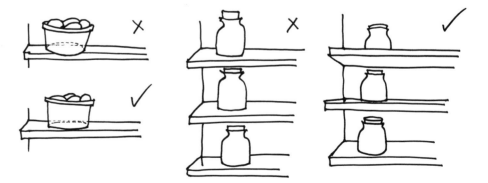

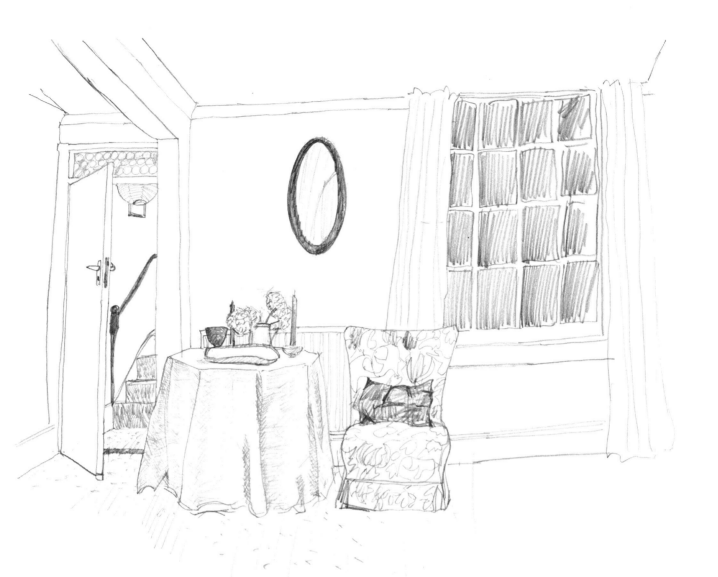

Often you can't, or don't want to, spend very long on a drawing. In that case, go for essentials and be bold. It is quite possible to draw boldly *and sensitively*. This, deliberately, is a quick, rough sketch of one wall; but it has been given a sense of depth by the view through the open door, the lines on the floor and the volume of chair and table (see diagram). I treated the window and curtains sketchily, since they didn't help to develop the volume of the objects and the sense of depth—which I felt were the most interesting features.

One object from different angles

Try drawing something from different angles, noticing how its shape apparently changes as you change your position.

Concentrate on what you see before you, not on your knowledge of what the object itself is like. The drawing will take care of itself and look 'right' if you put down faithfully, and with full concentration, what you see.

All the same, make a careful close-up inspection before you start, since it is always easier to draw a subject if you understand how it works.

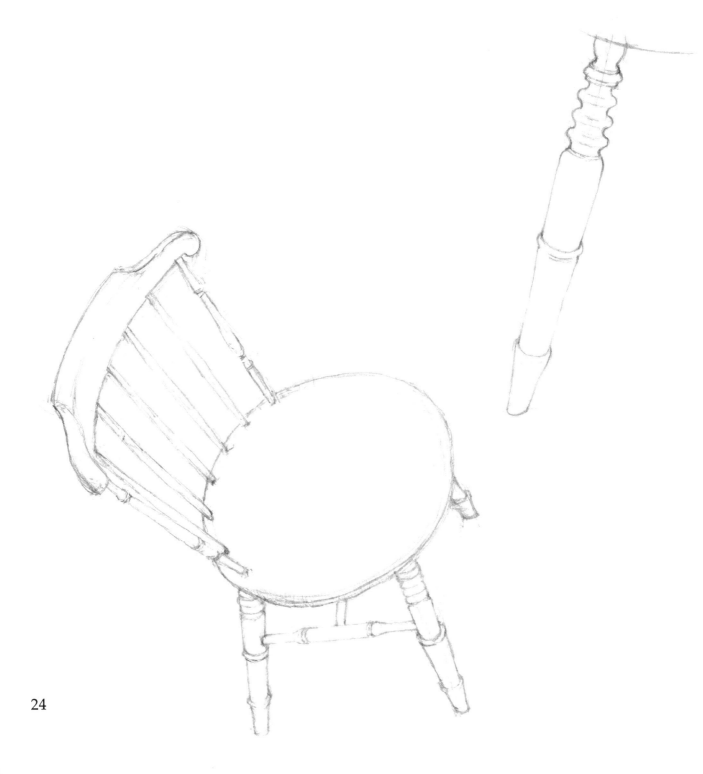

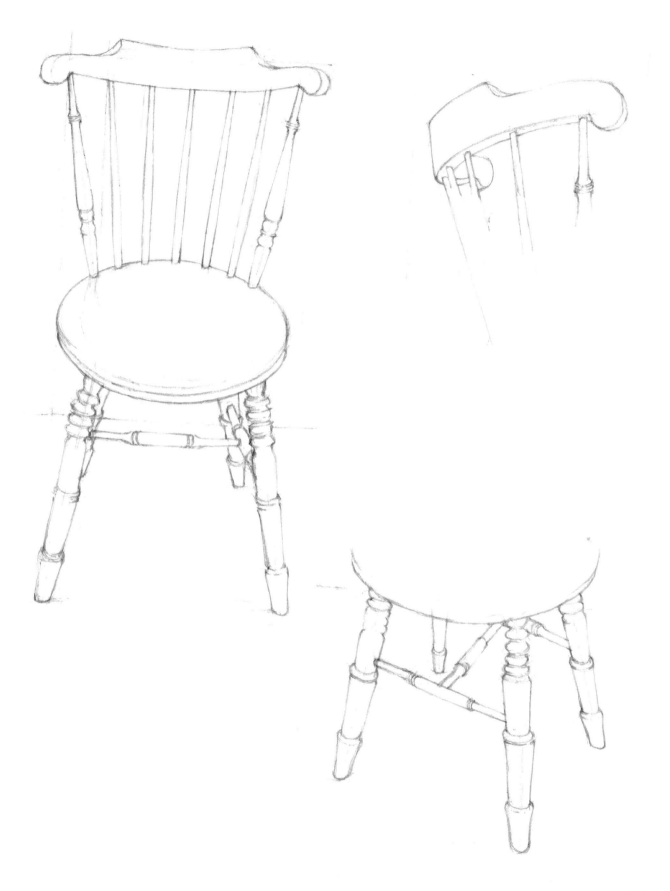

25

Useful tips for complicated scenes

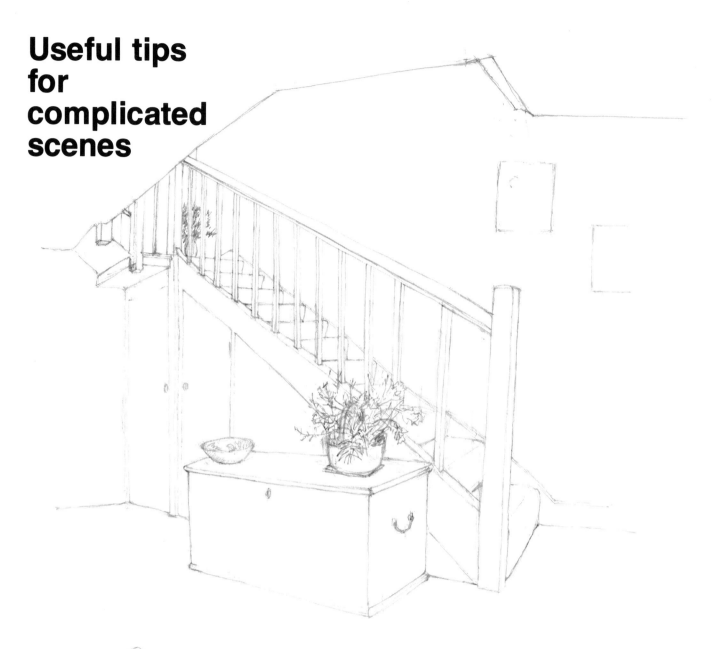

Stairs present problems in perspective which can be fun to solve. If you draw from below, the higher steps are smaller than the lower ones because they are further away, and the amount of each top surface that you see gradually decreases, and finally disappears altogether.

Try drawing each step as a shape on a flat surface. It helps to see the scene in two, rather than three, dimensions if you half-close your eyes.

In the above drawing, it was also useful to see each pair of bannister posts as a frame for the shape made by the step beyond. The diagrams on the right show the basic shapes and perspective lines of the finished sketches.

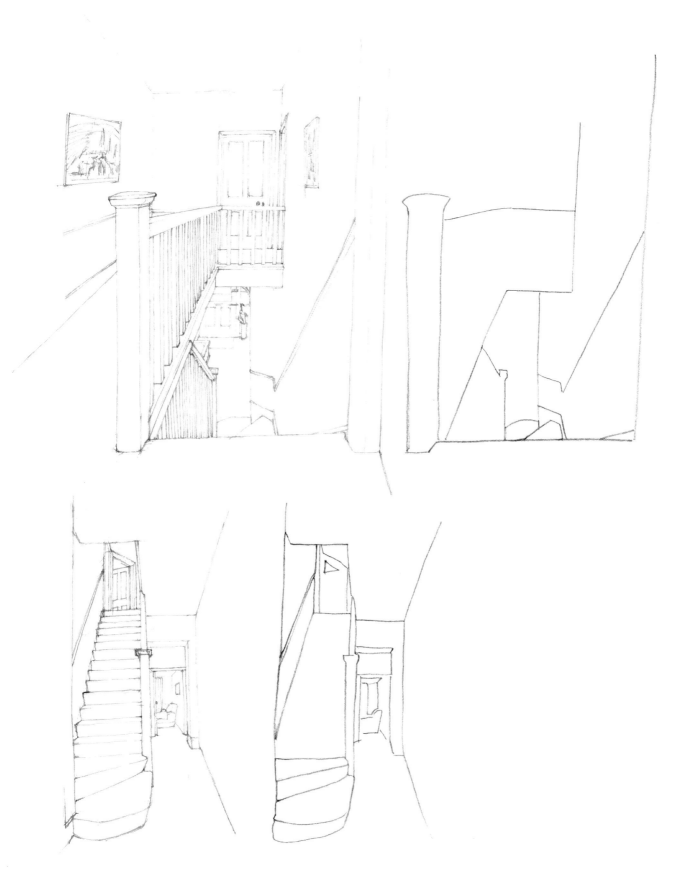

Size and scale

The easiest size to draw is sight-size. Take measurements with your thumbnail on a pencil held at arm's length, and then transfer them exactly onto your paper. If you want to draw bigger or smaller than sight-size, you can only do it by comparison.

The relationship between objects and the proportions of these objects are what matters. Once you have made one part of your drawing the size you want, this part can be used as a norm to establish the size of everything else.

However big or small your drawing, the proportions and shapes shouldn't alter. To understand this, stay in one place yourself and try drawing your object or scene in different sizes. The blank areas between objects are just as important as the objects themselves; a wrongly-drawn space will spoil your picture just as much as a wrongly-drawn object.

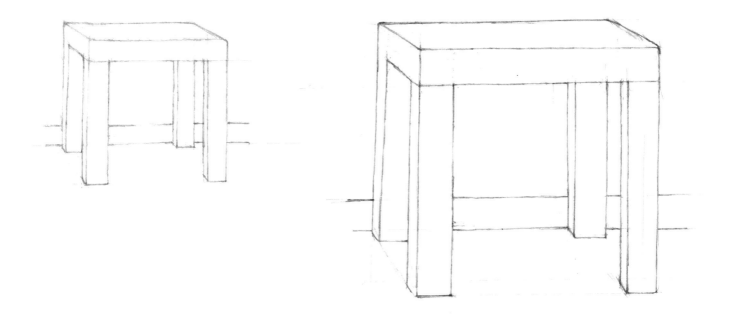

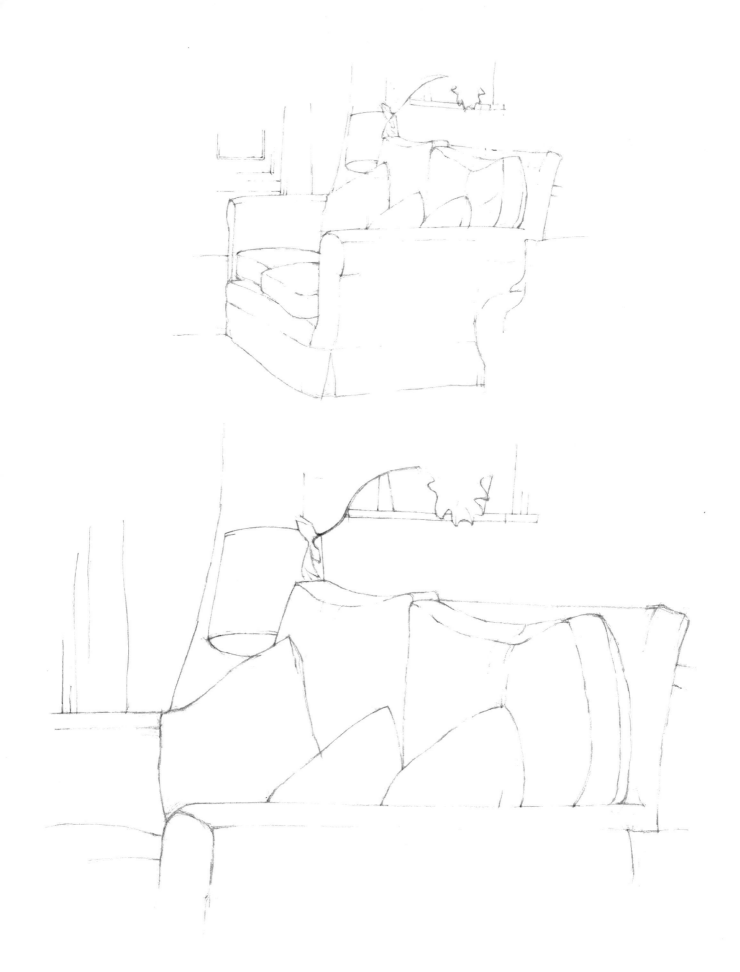

Step by step: putting up scaffolding

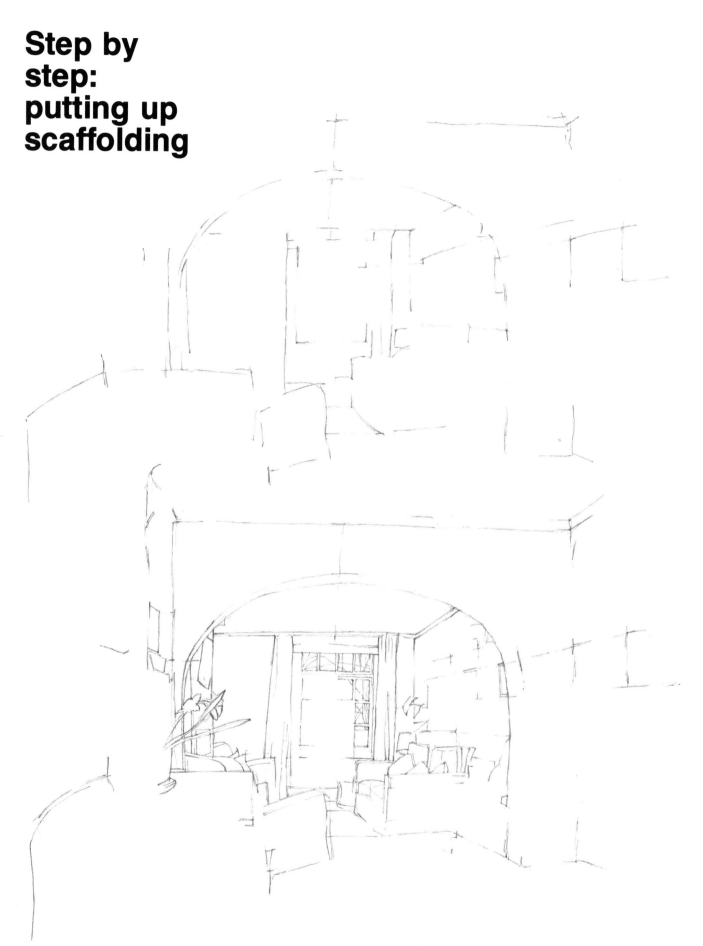

In this drawing no one part is more important than another. In such cases, it is easiest to start by making a framework of reference marks which pin things faintly in place. You can then gradually build up all parts of the drawing at the same time.

Be ready to alter any mark (though not necessarily to rub it out) as your drawing progresses and your observation becomes more accurate.

Constantly relate one object to another and one space to another, and remember it is easier to relate horizontally and vertically than it is to judge the angles of diagonals.

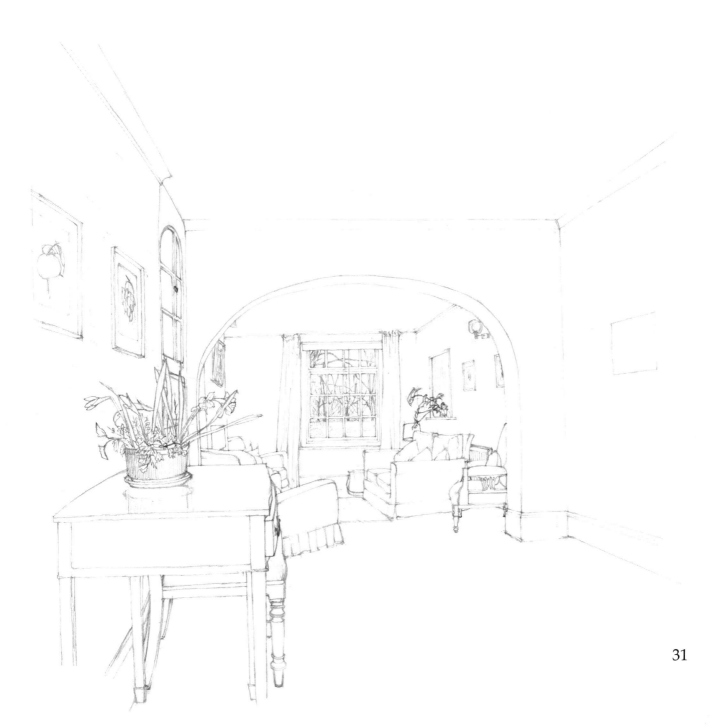

Step by step: building out from the centre

Here, in contrast to the example on the previous page, I found one object in the scene I was drawing more interesting than any other—the chair in the corner of the room. Since there was also little symmetry in the composition, I began by drawing the chair in detail (as shown) and then built up the rest of the picture around it.

There was enough reference within the chair, in the form of its checked upholstery and metal frame, to build outwards by relating each mark to an adjoining one. I used a B carbon pencil, which has a pleasant, slightly gritty texture. The view through the window added depth to the composition.

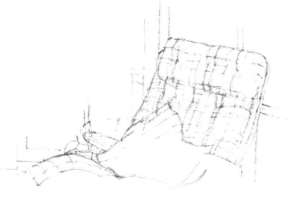

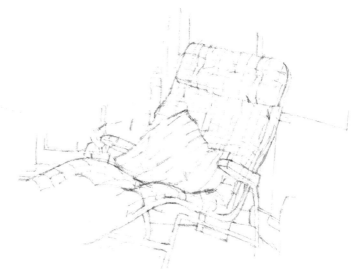

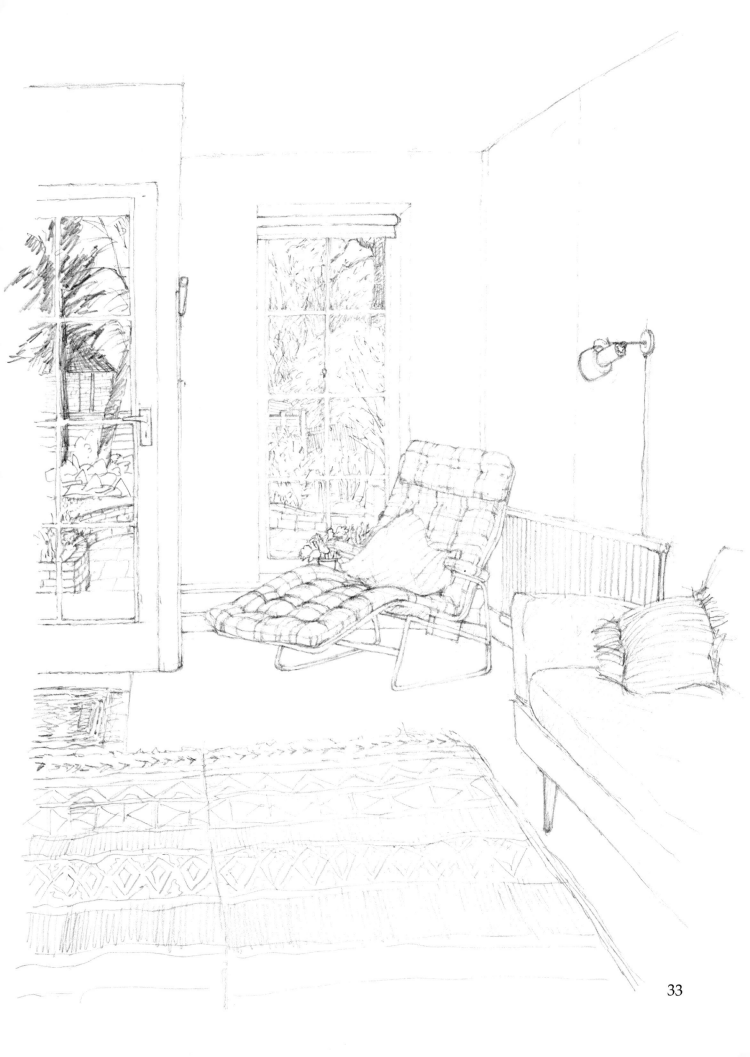

33

Tricks
perspective
can play

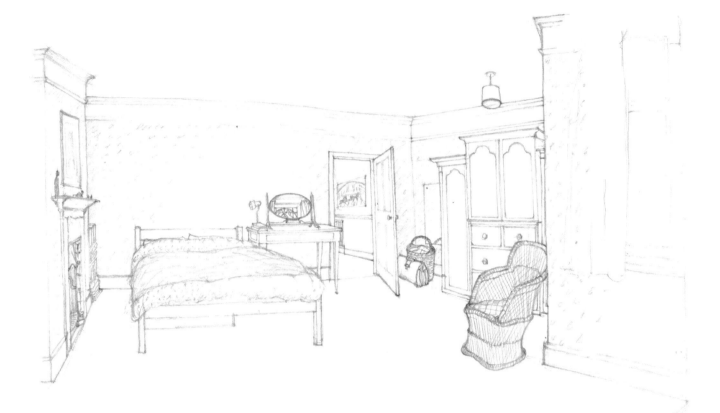

This drawing illustrates a number of perspective problems—some fairly obvious, some less so—which you are bound to come across when drawing an interior.

I drew from a corner of the room, which meant that I had to turn my head constantly to observe and draw either end. The result is a kind of bulging fish-eye perspective. The far wall was, of course, straight but, as I drew, I realised that the top and bottom looked curved—the part directly opposite me being the peak and biggest point of the curve. Then, the bottom of the bed looked bigger than the top and the length appeared much fore-shortened. (In the drawing, the bed's length is, in fact, less than the height of the fireplace which, in reality, is only about three feet high.)

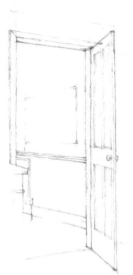

The picture above the fireplace and the fireplace itself looked much narrower than I had expected. The top of the door-frame and the wooden rail down the passage are really at right-angles to each other, but they appeared parallel to me, and of course 'appearance' is what drawing is about.

Notice that the door doesn't *look* as wide as its frame.

In reality, too, the chair is much smaller than the door but, from where I was sitting, they seemed the same size—a fact which I confirmed by measuring them against my pencil.

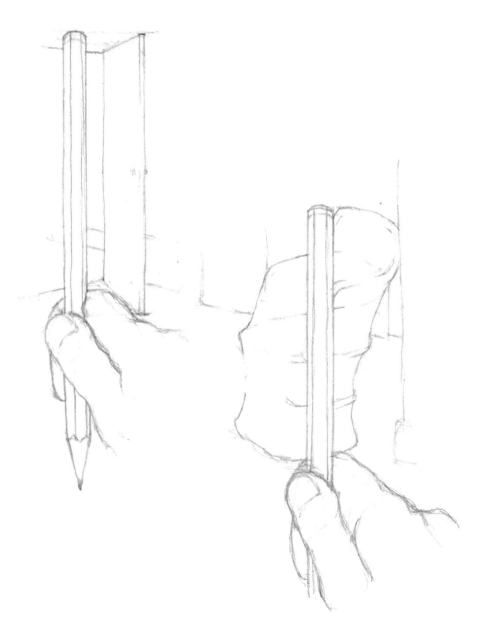

Surfaces and textures

There is a wide variety of surface and texture in any home. To appreciate this, try drawing an object, such as the lamp here, on a polished table, or a bare, angular wooden chair and a cosy, upholstered armchair next to each other.

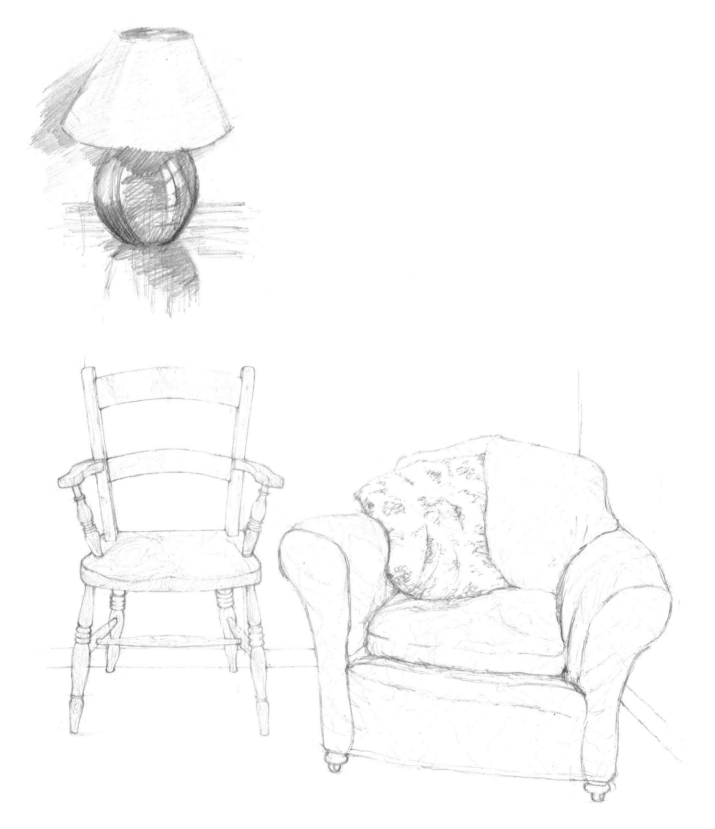

Contrast the bold, ink technique below with the careful, pencil
one on the right. I don't think of either drawing as 'better'
than the other; each tried to capture the texture of its subject.

Notice how the folds of a curtain become looser towards the
bottom. Try drawing curtains of different materials and
weights and see how differently they hang.

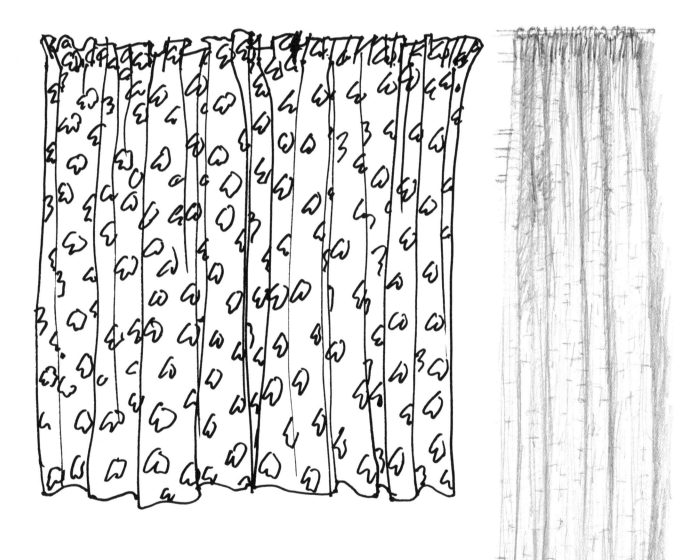

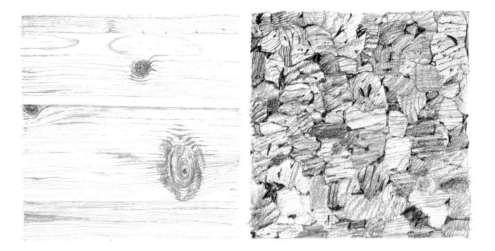

Experiment with different media. I used an H pencil to show the fine variation in line on the surface of the pale, fine-grained unpolished pine above. The grain of a polished wood looks more smudged and less well defined.

I used a B carbon pencil and an HB pencil for the dark wall cork, right. Notice the squashy shapes with no hard edges or corners.

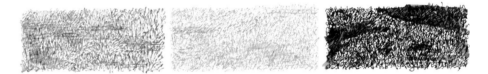

Above: towelling in different media: 2B pencil, H pencil, and fountain pen with a little water.

Below: two different sorts of basket-weaving, one drawn in pen-and-wash, the other in pencil.

Suggesting colour

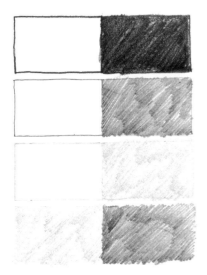

You can suggest colour through black and white drawing by concentrating on tonal constrasts, shading in varying degrees of strength, from dark to light.

Try using different pencils next to each other. In the right of the diagram here, I used first a 6B pencil, then an HB, then a 6H. Notice how much whiter the shape next to the darkest 6B pencil appears in comparison with the two white ones below it. The lowest section of the diagram shows a 6H pencil next to an HB. You can achieve an enormous variety of tone by contrasting different pencils.

The drawing below was done in writing ink, and smudged with a little water. The range of tones was then built up with a brush and concentrated watercolour ink, diluted to different strengths.

39

Light and shade

To study the effect of light and shade, try drawing the same subject at different times of day or night, choosing a suitable medium to illustrate the particular effect of the lighting.

The drawing below was done at night, with the light coming from the lamp behind the chair. I used charcoal to produce a black, smudgy effect which, helped by the whiteness of the paper, shows sharp contrasts between the brightly-lit parts of the corner and those in deep shadow.

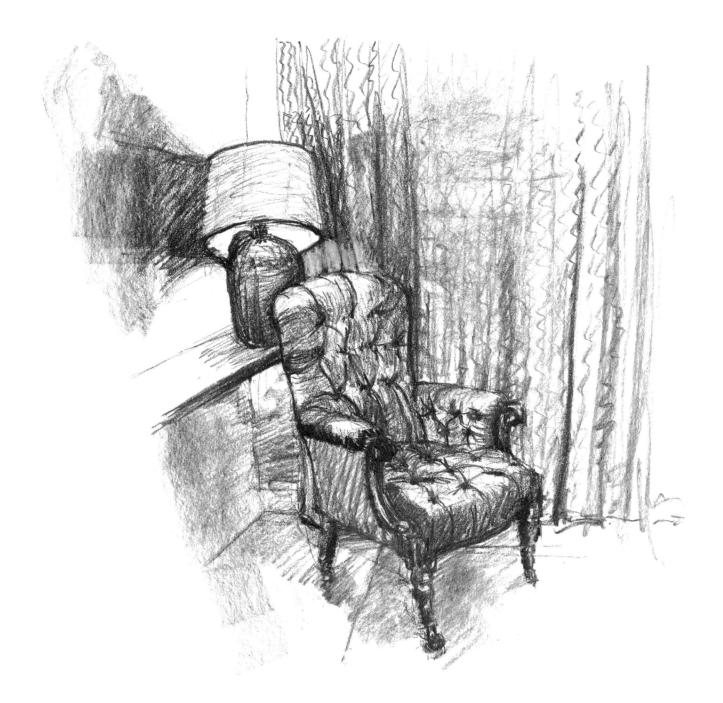

This drawing of the same subject was done in daylight, with the curtain drawn back and light coming in through the window. I used a Conté crayon. If the sun had been shining, the contrast between light and shade would have been greater; but it was a dull day, shedding a soft, even light—very different from the localised light opposite.

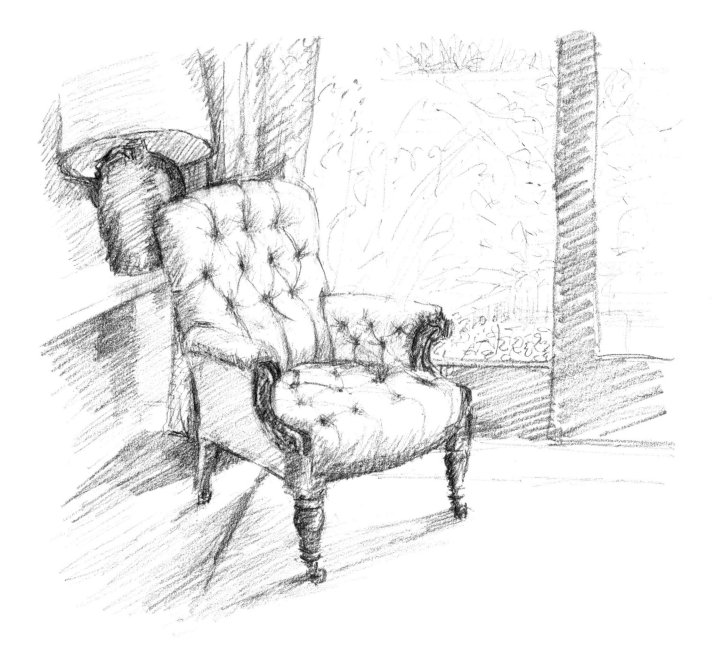

Tackling a large building

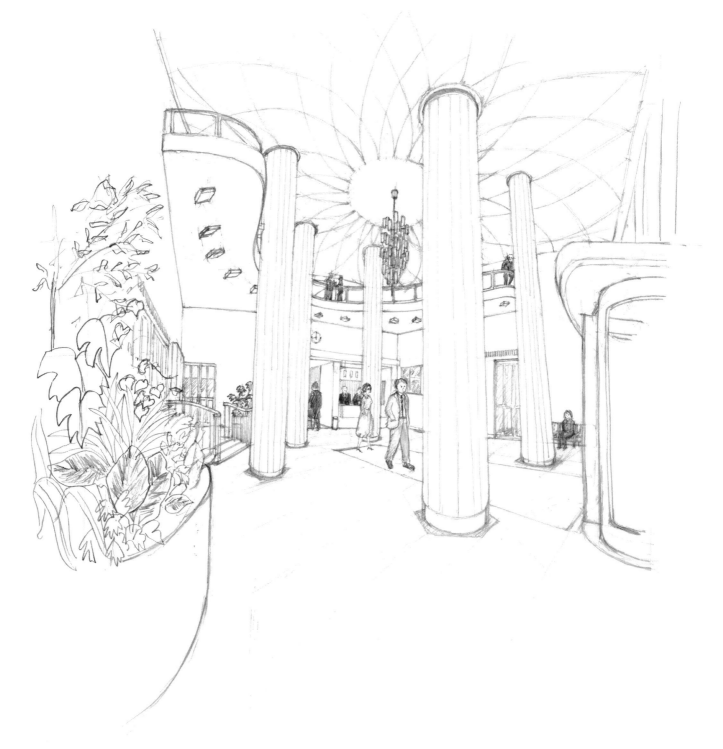

In larger buildings, distances and spaces are greater, and the perspective distortions will tend to be greater also. Before starting the drawing itself, make a few quick sketches in order to 'feel' the perspective.

My sketches for the drawing opposite showed me that the pillars seemed to bend inwards on one another towards the ceiling, and that this was an important feature.

When I started the main drawing, I lightly drew the lines of the far wall and the balcony through the pillars, to make sure they were in the right places when they emerged on either side.

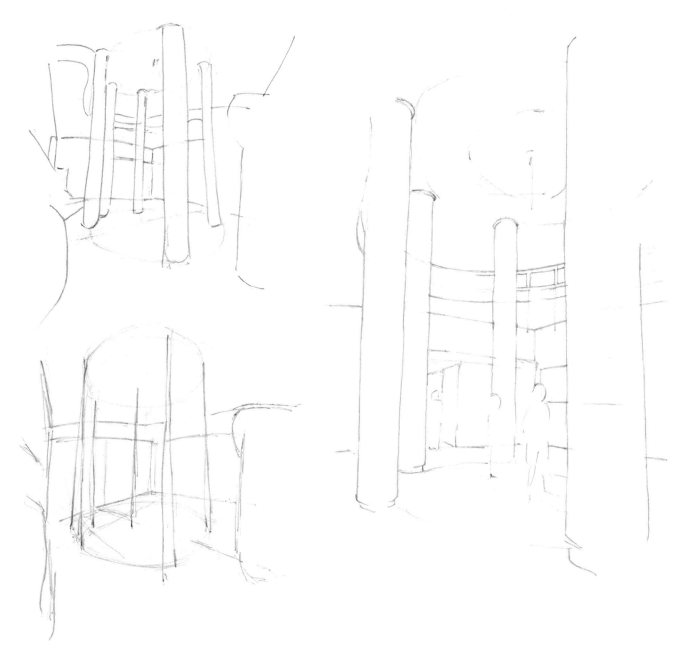

People in public buildings

When drawing the interior of a public building, such as a swimming bath or railway station, remember that people not only indicate scale but give life to the subject. In fact even in a drawing like this, where the figures are merely sketches, it is clear that the buildings are only interesting because of the life going on inside.

Start by drawing the main shapes of the building, to provide a framework for the people. But don't fill in the details of the building until the figures have been inserted, otherwise you will find yourself drawing people on top of details, and both will look confused.

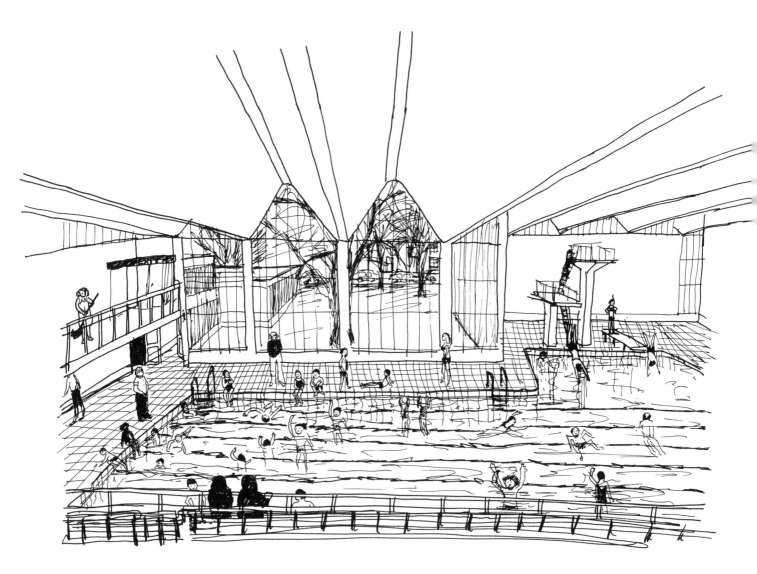

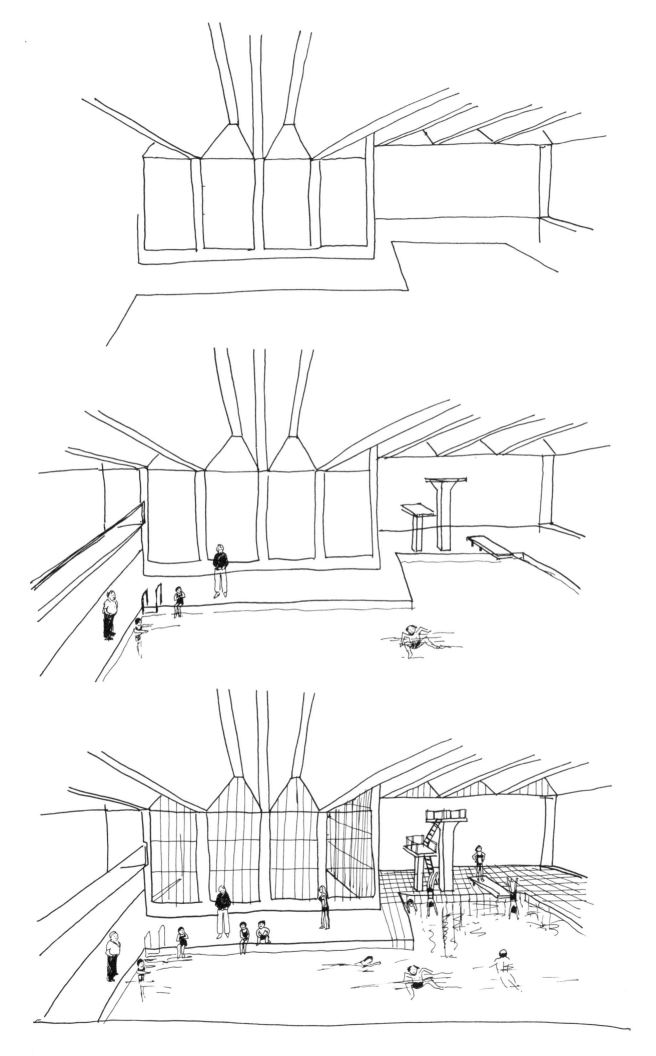

45

Sketching as a record

Quick sketches of people in public places will sharpen your observation. They can also serve as a pictorial record of places you have visited or outings you have been on. Practise drawing whenever you can. Always carry a small sketchbook and sketch in it people whose facial expressions, clothes or movements amuse or interest you. This needn't be embarrassing or conspicuous. You can usually draw quite unobtrusively from a corner of a room, through a window or in a mirror.

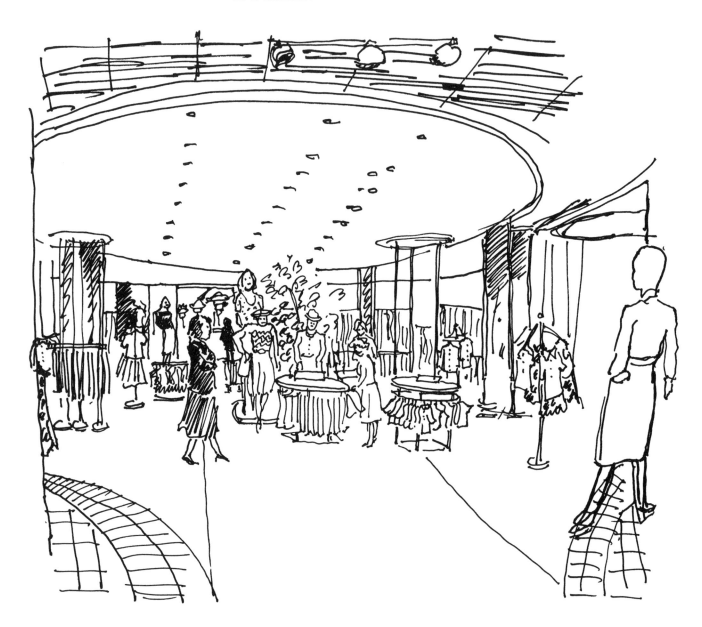

Left: while waiting for
someone
in a shop. Felt tip pen.

Right: on the London
Underground.
Notice the wobbly lines
caused by
the train's movement.
Fountain pen,
underside of nib.

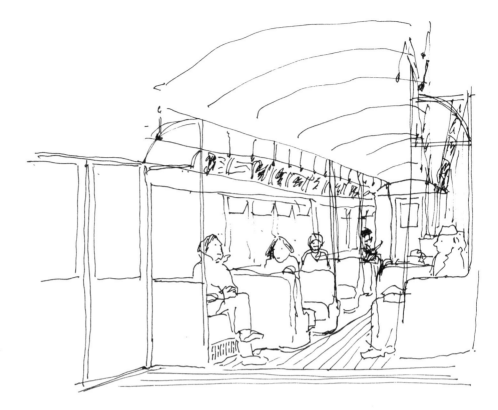

Below: In the mirror of a
tiny café.
Fountain pen.

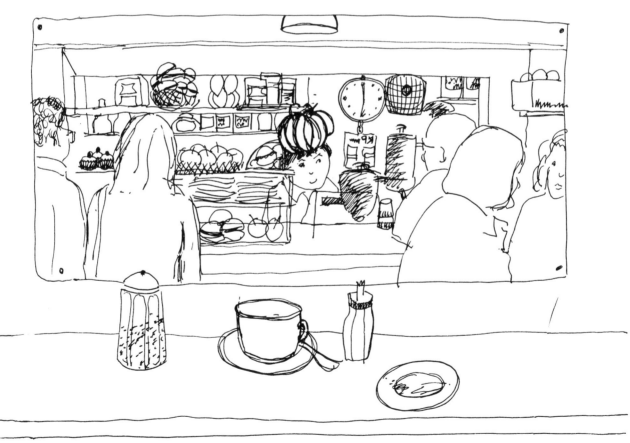

Historic house

When you become reasonably confident about your drawing, try a major composition such as the interior of a historic house.

Don't be put off by the ornateness of a room; the basic structure underneath is quite simple.

You need staying power for an ambitious drawing. There are bound to be times when you feel your inspiration has deserted you; but if you persevere, it will return. When drawing in a public place, choose a quiet spot to sit or stand; you don't want to have to move every five minutes to let someone past. Be as tidy as possible and try not to worry officials by producing large bottles of ink that might tip over and spoil a carpet or floor. Keep your materials in a neat pile, rather than spread out all over the place. You are less likely to be disturbed if you are careful about these things.

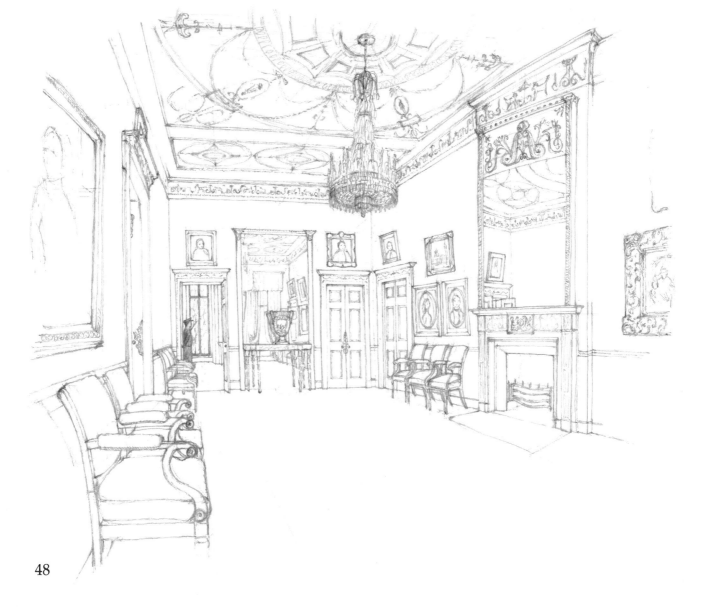